Getting Around in Chinese

Chinese Skits for Beginners

Hilda H. Tao

© 2000
By Regents of the University of Michigan
All rights reserved

Published by
Center for Chinese Studies
The University of Michigan
Ann Arbor, MI

First Edition

Illustrations by Yumei Wiltse
Cover design by Margot Campos

Printed in the United States of America

9 8 7 6 5 4 3 2 1

Acknowledgments

This whole project started in April 1999 and took us seventeen months to complete. "Getting Around in Chinese," including video, CD-ROM, and scriptbook, is the result of the work of many devoted people. I am truly grateful to everyone who participated.

First and foremost, I would like to thank Professor Ernest Young, Director of the Center for Chinese Studies here at the University of Michigan. Professor Young and the Center's Executive Committee provided funding and support without which this project would never have come about. I would also like to thank Dr. Monika Dressler, Director of the Language Resource Center, for her financial and technical support of production of the video and CD.

It was Professor Tom Buoye, an old friend visiting at the China Center, who approached me and got the project started. I have appreciated Professor Buoye's counsel and encouragement along the way.

I am also deeply indebted to Professor William Baxter, Coordinator of the Chinese Program in the Department of Asian Languages and Cultures. Professor Baxter spent hours helping me solve problems with the pinyin font, and simplified characters. On numerous occasions, he offered suggestions and advice related to this manuscript.

I would also like to thank the team of talent who acted in the video. Besides myself, the other talent include Chia-Hung Chou, Dongzhe Guo, Yu-Jin Kung, Mei Li, and Wei Wang. They were the most patient talent one could ever hope to find. My gratitude goes to all of them for their willingness to cooperate in every possible way. And I can hardly thank enough Kathryn Lee of the Language Resource Center, who directed and produced all the skits.

Special thanks to Noriko Kamachi, Director of Publications for the Center for Chinese Studies, for her support. Thanks also to Terre Fisher, who did a tremendous job of editing this book. Many thanks to Yumei Wiltse for the lively illustrations that brighten up each skit.

Lastly, I am very grateful to my brother Hsi-Liang, and my three sisters Hsi-Jen, Hsi-Guang, and Hsi-Ping for going over the first draft of the skits and giving me many valuable suggestions.

Author's Introduction

This book contains the text of twenty-seven skits for the beginning student of Chinese. These skits are available in both video and CD-ROM (QuickTime format). This is not meant to be a stand-alone teaching unit. The video, CD-ROM, and scriptbook are best used as supplementary materials for any of the beginning Chinese textbooks now available. These skits are based on ones that I began working on nearly ten years ago. I am very pleased that they will now be available for students of Chinese everywhere.

The History of Skits for Beginners

I started teaching First Year Chinese at the University of Michigan in 1968, but the idea of asking students to do skits did not come to me until 1982. At that time I had a few students whose pronunciation was quite impressive, and they were enthusiastic about learning Chinese. I thought it would be helpful if I could videotape their performance. So I wrote a short skit and asked them to perform it while the language lab staff videotaped them. The students were much encouraged, and they practiced intensively. They actually took great delight in doing the videotaping. Later that winter, we did another session. Everyone was very excited about this activity.

Encouraged by this positive response, I realized that videotaping their performances would motivate students to improve their pronunciation and fluency. Because they all wanted to be their best in front of the camera, I found that they practiced more on their own outside class. They were self-motivated.

Starting in 1987, all First Year Chinese students were required to form small groups and, working together, create their own skits at the end of the second semester. The skits were then videotaped and the students' performances counted as part of their final grade. But this was still only a once-a-year activity, and we continued it that way for five years.

In 1992 we tried something different. Students were asked to role-play in a series of pre-constructed skits, and skit performance became a regular exercise over the course of the semester. By 1997, skit performance had become almost a weekly activity, even in the first semester of First Year Chinese.

Why Skits?

Aside from being excellent motivators, skits help students improve their grasp of the Chinese language in several ways:

1. Skits help students learn what to say in a given situation.

 Students may have learned a lot of grammar, but they may not know what to say when a particular situation comes up. For example, if someone compliments you on how good your Chinese is, what do you say? If you want to bargain at a market, how do you do that? How do you turn down a dinner invitation graciously or ask a friend to the movies? These skits were written to help students learn how to handle these and other social interactions.

2. Skits help students learn or review points of grammar.

 Each skit in this book is also written with a grammatical point in mind. For example, the 'shí . . . de' pattern is introduced in Skits 16 and 17, the 'how often' pattern appears in Skit 23, and the 'V+ guò' pattern in Skit 24.

3. Through skits, students learn practical vocabulary.

 A few skits were written mainly to teach students certain useful vocabulary items. In 'Talking About the Weather' for example, they learn to actively use words such as hot, cold, snow, spring, summer, fall, and winter. In the skit about moving, students must master terms such as apartment, kitchen, bedroom, and to pay rent, as well as common spoken expressions like 'Of course!' that make their Chinese natural rather than bookish.

4. Skits help students practice and improve tones and pronunciation.

 With regard to learning pronunciation, in-class practice under the teacher's guidance is of course critical. Outside class, the CD-ROM version of the skits is especially helpful because students can listen to the same sentence as many times as they need to with just a click of the mouse. By watching the speaker's mouth and listen to the sound at each practice session, students have a better chance to learn correct pronunciation. Using the CD-ROM, students can easily work on a skit before class and also practice more afterward.

Organization of the Skits

The order of the skits in this scriptbook matches their order on the video, but that order is largely arbitrary. There was no way to number them so that they would be perfectly compatible with all the different textbooks we teachers of First Year Chinese use at our various institutions. You should feel free to pick whichever skit is the most appropriate for any given week of your term.

Each skit has five parts:
1. Dialogue in Hanyu pinyin
2. English translation of the dialogue
3. Vocabulary and phrases in pinyin, English and Chinese characters
4. Dialogue in traditional Chinese characters
5. Dialogue in simplified Chinese characters

Today every student learns pinyin and should find the text easy to work with. We provide an English translation to help students prepare the skits before class.

Items in the vocabulary lists are given in the order they appear in the dialogues for easy reference. We have also included the dialogues in characters for the reference of those students of Chinese who read Japanese or Korean.

Suggestions for Using These Skits

1. During the week I select one or two skits that relate to a topic or pattern the students have already learned. We begin by working on pronunciation.

2. Skit quiz is a weekly activity. Students are required to role-play and are graded on their pronunciation, fluency, and mistakes. Students find their own partners for practice each week.

Students are graded on their performance in pairs in front of the class. The teacher can set up a very objective grading system: If students make one to five mistakes, they get an A, six to ten mistakes gives them an A-, and so forth.

3. Toward the end of the second semester, students are expected to create and perform a six- to seven-minute conversation that uses material from at least fifteen of the skits they have learned. Their final performance of this conversation is then videotaped in a studio. The teacher reviews the tapes later to decide their grades. Grades are based on (a) pronunciation, (b) fluency, and (c) overall performance, which includes effort put into preparation.

4. Students' weekly skit performances and the final performance together make up 25 percent of their course grade.

5. Other possible ways to use these skits:
 a. For listening comprehension: pick a skit and play it a couple of times for the students, then ask them questions about it afterward;
 b. For dictation: play a skit and ask the students to write down the pinyin or Chinese characters;
 c. For review purposes: skits make a quick and efficient way of reviewing basic patterns and vocabulary at the beginning of Second Year Chinese.

I myself am still discovering new ways to use these materials to help my students improve their Chinese. If you find a new or better way of using them, or would like to give me feedback on them, I would be very grateful. We can learn from each other. Please contact me by e-mail at the address below.

Hilda Tao
htao@umich.edu
University of Michigan
Summer 2000

Contents

Skit 1	Introductions 您貴姓?		1
Skit 2	Greetings 你好嗎?		5
Skit 3	At a China Goods Store 在中國店		9
Skit 4	What Time Do You Get Out of Class? 你幾點鐘下課?		13
Skit 5	Turning Down an Invitation 真對不起! 我有事.		17
Skit 6	Talking About the Weather 談天氣		21
Skit 7	Where Do You Live? 妳住在哪兒?		25
Skit 8	Inviting a Friend to Your House for Dinner 請朋友來家裏吃晚飯		29
Skit 9	Giving Someone a Ride 開車接送朋友		33
Skit 10	Asking a Friend to a Movie 約朋友去看電影		37
Skit 11	How Long Does It Take to Get There? 開車去要多久?		43
Skit 12	Asking Directions 問路		47

Skit 13	Talking About Your Family 談家人	51
Skit 14	Buying a Gift 買禮物	55
Skit 15	You Speak Chinese Very Well! 你中文說得真好啊!	59
Skit 16	When Did You Start Learning Chinese? 你是甚麼時候開始學中文的?	63
Skit 17	When Did You Come to the U.S.? 你甚麼時候到美國來的?	67
Skit 18	I Like Your Outfit! 妳這件衣服真漂亮!	71
Skit 19	When is Your Birthday? 妳生日是哪天?	75
Skit 20	What's Your Major? 你是學甚麼的?	79
Skit 21	What Do You Plan to Do After Graduation? 畢業以後, 你打算做甚麼?	83
Skit 22	Moving to a New Apartment 搬家	87
Skit 23	How Often Do You Call Your Parents? 你多久給父母打一次電話?	91
Skit 24	Have You Ever Been to China? 你去過中國嗎?	95
Skit 25	How Long Have You Known Each Other? 你們認識多久了?	101
Skit 26	Asking for a Phone Number and Address 要電話地址	105
Skit 27	What Are You Going to Do This Summer? 今年暑假妳打算做甚麼?	109

Skit 1
Introductions 您贵姓?

Skit 1
Introductions 您貴姓？

Dialogue: Pinyin

1. 1. Qǐng wèn, nín guì xìng?
 2. Wǒ xìng Táo.

2. 1. Nín shì Táo lǎoshī ma?
 2. Shì de. Nǐ jiào shénme míngzi?

3. 1. Wǒ xìng Tián. Wǒ míngzi jiào Tián Ān.
 2. A! Tián Ān.

English Translation

1. 1. May I ask, what is your (honorable) family name?
 2. My family name is Tao.

2. 1. Are you Teacher Tao?
 2. Yes. What's your name?

3. 1. My family name is Tian, my name is Tian An.
 2. Ah! Tian An.

Skit 1: Introductions

Vocabulary & Phrases

1.	qǐng wèn	May I ask? (Used like 'excuse me.')	請問
2.	qǐng	please	請
3.	wèn	to ask	問
4.	nín	you (polite form)	您
5.	guì xìng	your (honorable) family name?	貴姓
6.	guì	honorable	貴
7.	xìng	family name	姓
8.	wǒ	I, me	我
9.	Táo	a family name	陶
10.	shì	verb 'to be'	是
11.	lǎoshī	teacher	老師
12.	ma	*question particle*	嗎
13.	shì de	yes	是的
14.	nǐ	you	你
16.	jiào	to be called	叫
17.	shénme	what?	甚麼
18.	míngzi	name	名字
19.	Tián	a family name	田
20.	Ān	a first name	安
21.	a	ah!	啊

Skit 1

Dialogue: Traditional Characters

1. 1. 請問, 您貴姓?
 2. 我姓陶.

2. 1. 您是陶老師嗎?
 2. 是的. 你叫甚麼名字?

3. 1. 我姓田. 我名字叫田安.
 2. 啊! 田安.

===

Simplified Characters

1. 1. 请问, 您贵姓?
 2. 我姓陶.

2. 1. 您是陶老师吗?
 2. 是的. 你叫什么名字?

3. 1. 我姓田. 我名字叫田安.
 2. 啊! 田安.

Skit 2
Greetings 你好嗎?

Skit 2
Greetings
你好嗎?

Dialogue: Pinyin

1. 1. Tián Ān, hǎo jiǔ bú jiàn! Nǐ hǎo ma?
 2. Hěn hǎo! Nǐ ne?

2. 1. Hái bú cuò! Nǐ zuìjìn máng ma?
 2. Fēicháng máng!

3. 1. Zàijiàn!
 2. Zàijiàn!

English Translation

1. 1. Tian An, long time no see! How are you?
 2. Very good! And you?

2. 1. Not bad! Have you been busy lately?
 2. Very busy!

3. 1. Good-bye!
 2. Good-bye!

Skit 2: Greetings

Vocabulary & Phrases

1.	hǎo jiǔ bú jiàn	Long time no see!	好久不見
2.	hǎo	good, fine	好
3.	jiǔ	long time	久
4.	bú	no, not	不
5.	jiàn	to see	見
6.	hěn	very	很
7.	nǐ ne	How about you?	妳呢
8.	nǐ	you (female)	妳
9.	ne	*question particle*	呢
10.	hái bú cuò	not bad, okay	還不錯
11.	zuìjìn	lately, recently	最近
12.	máng	busy	忙
13.	fēicháng	very, extremely	非常
14.	zàijiàn	good-bye, see you!	再見

Skit 2

Dialogue: Traditional Characters

1. 1. 田安, 好久不見! 你好嗎?
 2. 很好! 妳呢?

2. 1. 還不錯! 你最近忙嗎?
 2. 非常忙!

3. 1. 再見!
 2. 再見!

Simplified Characters

1. 1. 田安, 好久不见! 你好吗?
 2. 很好! 妳呢?

2. 1. 还不错! 你最近忙吗?
 2. 非常忙!

3. 1. 再见!
 2. 再见!

Skit 3
At a China Goods Store
在中國店

Skit 3
At a China Goods Store
在中國店

Dialogue: Pinyin

1. 1. Qǐng wèn, jiǎozi duōshǎo qián yì bāo?
 2. Jiǔ kuài wǔ máo qián yì bāo.

2. 1. Wǒ mǎi sān bāo. Kě bu kěyǐ piányi diǎnr?
 2. Sān bāo suàn nǐ èrshíqī kuài qián.

3. 1. Kuàizi yì bāo duōshǎo qián?
 2. Kuàizi bā máo jiǔ yì bāo.

4. 1. Wǒ kě bu kěyǐ yòng xìnyòng kǎ?
 2. Duìbuqǐ, wǒmen bù shōu xìnyòng kǎ.

English Translation

1. 1. Excuse me, how much is one bag of dumplings?
 2. $ 9.50 a bag.

2. 1. I'll buy three bags. Can you lower the price a little?
 2. Okay. For three bags, I'll charge you $27.

3. 1. How much is one pack of chopsticks?
 2. Eighty-nine cents a pack.

4. 1. Can I use a credit card?
 2. Sorry, we don't accept credit cards.

Skit 3: At a China Goods Store

Vocabulary & Phrases

1.	jiǎozi	dumplings	餃子
2.	duōshǎo	how much?	多少
3.	duō	a lot, much	多
4.	shǎo	a little, few	少
5.	qián	money	錢
6.	yì bāo	per bag	一包
7.	yī	one	一
8.	bāo	bag (*measure word*)	包
9.	jiǔ	nine	九
10.	kuài	dollars	塊
11.	wǔ	five	五
12.	máo	dimes	毛
13.	mǎi	to buy	買
14.	sān	three	三
15.	kěyǐ	can, may	可以
16.	piányi	cheap	便宜
17.	diǎnr	a little bit	點兒
18.	suàn	to figure, to count	算
19.	èrshíqī	twenty-seven	二十七
20.	èr	two	二
21.	shí	ten	十
22.	qī	seven	七
23.	kuàizi	chopsticks	筷子
24.	bā	eight	八
25.	yòng	to use	用
26.	xìnyòng kǎ	credit card	信用卡
27.	xìnyòng	credit, trustworthiness	信用
28.	kǎ	card	卡
29.	duìbuqǐ	I'm sorry!	對不起
30.	wǒmen	we	我們
31.	shōu	to accept, to receive	收

Skit 3

Dialogue: Traditional Characters

1. 1. 請問, 餃子多少錢一包?
 2. 九塊五毛錢一包.

2. 1. 我買三包. 可不可以便宜點兒?
 2. 三包算你二十七塊錢.

3. 1. 筷子一包多少錢?
 2. 筷子八毛九一包.

4. 1. 我可不可以用信用卡?
 2. 對不起, 我們不收信用卡.

Simplified Characters

1. 1. 请问, 饺子多少钱一包?
 2. 九块五毛钱一包.

2. 1. 我买三包. 可不可以便宜点儿?
 2. 三包算你二十七块钱.

3. 1. 筷子一包多少錢?
 2. 筷子八毛九一包.

4. 1. 我可不可以用信用卡?
 2. 对不起, 我们不收信用卡.

Skit 4
What Time Do You Get out of Class?
你幾點鐘下課?

Skit 4
What Time Do You Get out of Class?
你幾點鐘下課？

Dialogue: Pinyin

1. 1. Míngtiān nǐ yǒu jǐ táng kè?
 2. Míngtiān wǒ yǒu sì táng kè.

2. 1. Nǐ jǐ diǎnzhōng xià kè?
 2. Wǒ wǔ diǎn xià kè. Yǒu shì ma?

3. 1. Míngtiān yòu shì xīngqīwǔ le. Wǒ xiǎng qǐng nǐ kàn diànyǐngr.
 2. Nǐ yòu yào qǐng wǒ a? Bù xíng! Bù xíng! Zhè cì gāi wǒ qǐng nǐ le!

4. 1. Hǎo ba!

English Translation

1. 1. How many classes do you have tomorrow?
 2. Tomorrow I have four classes.

2. 1. What time do you get out of class?
 2. I get out at 5 o'clock. What's up?

3. 1. Tomorrow is Friday again. I'd like to invite you to a movie.
 2. You're inviting me again? Oh no! This time it's my turn to invite you!

Skit 4: What Time Do You Get Out of Class?

4. 1. Okay!

Vocabulary & Phrases

1.	míngtiān	tomorrow	明天
2.	yǒu	to have	有
3.	jǐ	how many?	幾
4.	táng	*measure word* for classes	堂
5.	kè	class(es)	課
6.	sì	four	四
7.	diǎnzhōng	o'clock	點鐘
8.	xià kè	to get out of class	下課
9.	xià	to get off, to leave	下
10.	wǔ diǎn(zhōng)	5 o'clock	五點(鐘)
11.	yǒu shì ma	What's up?	有事嗎
12.	shì	matter	事
13.	yòu	again	又
14.	xīngqīwǔ	Friday	星期五
15.	xīngqī	week	星期
16.	le	*particle* indicating change of status	了
17.	xiǎng (+V)	would like to . . .	想 (+V)
18.	qǐng nǐ (+V)	to invite you to . . .	請你 (+V)
19.	kàn	to watch, to see	看
20.	diànyǐngr	movie	電影兒
21.	yào (+V)	to be going to . . .	要 (+V)
22.	xíng	okay	行
23.	zhèi (or zhè)	this	這
24.	cì	*measure word* for occurrence	次
25.	gāi	to be one's turn to V	該

Skit 4

Dialogue: Traditional Characters

1. 1. 明天你有幾堂課?
 2. 明天我有四堂課.

2. 1. 你幾點鐘下課?
 2. 我五點下課. 有事嗎?

3. 1. 明天又是星期五了. 我想請你看電影兒.
 2. 你又要請我啊? 不行! 不行! 這次該我請你了!

4. 1. 好吧!

==========

Simplified Characters

1. 1. 明天你有几堂课?
 2. 明天我有四堂课.

2. 1. 你几点钟下课?
 2. 我五点下课. 有事吗?

3. 1. 明天又是星期五了. 我想请你看电影儿.
 2. 你又要请我啊? 不行! 不行! 这次该我请你了!

4. 1. 好吧!

Skit 5
Turning Down an Invitation
真對不起! 我有事.

Skit 5
Turning Down an Invitation
眞對不起! 我有事.

Dialogue: Pinyin

1. 1. Míngtiān wǎnshàng nǐ yǒu kòng ma?
 2. Yǒu shénme shì ma?

2. 1. Wǒ xiǎng qǐng nǐ chī wǎnfàn.
 2. Míngtiān kǒngpà bù xíng, wǒ yǒu shì. Zhēn duìbuqǐ!

3. 1. Ou, méi guānxi! Nà, wǒmen gǎi tiān zài shuō ba.
 2. Hǎo.

English Translation

1. 1. Are you free tomorrow evening?
 2. Why, what's up?

2. 1. I'd like to invite you to dinner.
 2. Tomorrow I'm afraid it's not going to work. I have something else to do. I'm really sorry!

3. 1. Oh, that's okay! We'll try again another day.
 2. Okay.

Skit 5: Turning Down an Invitation

Vocabulary & Phrases

1.	wǎnshàng	evening	晚上
2.	kòng	free time	空
3.	chī	to eat	吃
4.	wǎnfàn	dinner	晚飯
5.	wǎn	late, evening	晚
6.	kǒngpà	I'm afraid that...	恐怕
7.	zhēn	really	真
8.	méi guānxi	it doesn't matter.	沒關係
9.	guānxi	to matter, to affect	關係
10.	nà	in that case . . .	那
11.	gǎi tiān	another day	改天
12.	gǎi	to change	改
13.	zài shuō	to consider later	再說
14.	zài	again	再
15.	shuō	to talk, to speak	說
16.	ba	*particle* indicating a suggestion	吧

Skit 5

Dialogue: Traditional Characters

1. 1. 明天晚上你有空嗎?
 2. 有甚麼事嗎?

2. 1. 我想請你吃晚飯.
 2. 明天恐怕不行, 我有事.　真對不起!

3. 1. 噢, 沒關係!　那, 我們改天再說吧.
 2. 好.

Simplified Characters

1. 1. 明天晚上你有空吗?
 2. 有什么事吗?

2. 1. 我想请你吃晚饭.
 2. 明天恐怕不行, 我有事.　真对不起!

3. 1. 噢, 没关系!　那, 我们改天再说吧.
 2. 好.

Skit 6
Talking About the Weather
談天氣

Skit 6
Talking About the Weather
談天氣

Dialogue: Pinyin

1. 1. Jīntiān de tiānqì zhēn hǎo a!
 2. Shì a. Bàoshàng shuō jīntiān de wēndù yào gāo dào qīshíwǔ dù!

2. 1. Shì ma? Zhèlǐ de qiūtiān zhēn piàoliang!
 2. Shì a. Nǐ kàn, zhè hóng yè duō měi!

3. 1. Nàme, zhèlǐ dōngtiān de tiānqì zěnmeyàng?
 2. Dōngtiān hěn lěng, chángcháng xià dà xuě.

4. 1. Nàme, xiàtiān ne?
 2. Xiàtiān fēicháng rè! Kěshì chūntiān hěn piàoliang!

English Translation

1. 1. Today's weather is really nice!
 2. Yes. The newspaper says the temperature will go up to 75 degrees!

2. 1. Really? The fall here is really beautiful!
 2. Yes. Look! The red leaves are so pretty!

3. 1. Well, how is the winter weather here?
 2. Winter is very cold; it often snows heavily.

Skit 6: Talking About the Weather

4. 1. And how about the summer?
 2. Summer is terribly hot! But spring is also very beautiful!

Vocabulary & Phrases

1.	jīntiān	today	今天
2.	tiān	day	天
3.	de	*possessive marker*	的
4.	tiānqì	weather	天氣
5.	bào shàng	in the newspaper	報上
6.	bào	newspaper	報
7.	wēndù	temperature	溫度
8.	gāo dào	go up to	高到
9.	qīshíwǔ	75	七十五
10.	dù	degree(s)	度
11.	zhèlǐ	here	這裏
12.	qiūtiān	fall, autumn	秋天
13.	piàoliang	beautiful	漂亮
14.	hóng	red	紅
15.	yè	leaves	葉
16.	duō měi	how pretty! so pretty!	多美
17.	nàme	well then, . . .	那麼
18.	dōngtiān	winter	冬天
19.	zěnmeyàng	how about . . . ?	怎麼樣
20.	lěng	cold	冷
21.	cháng (cháng)	often	常(常)
22.	xià xuě	to snow	下雪
23.	dà xuě	heavy snow	大雪
24.	dà	big	大
25.	xuě	snow	雪
26.	xiàtiān	summer	夏天
27.	rè	hot	熱

| 28. | kěshì | but | 可是 |
| 29. | chūntiān | spring | 春天 |

Skit 6

Dialogue: Traditional Characters

1. 1. 今天的天氣真好啊!
 2. 是啊. 報上說今天的溫度要高到七十五度!

2. 1. 是嗎? 這裏的秋天真漂亮!
 2. 是啊. 你看, 這紅葉多美!

3. 1. 那麼, 這裏冬天的天氣怎麼樣?
 2. 冬天很冷, 常常下大雪.

4. 1. 那麼, 夏天呢?
 2. 夏天非常熱! 可是春天很漂亮!

Simplified Characters

1. 1. 今天的天气真好啊!
 2. 是啊. 报上说今天的温度要高到七十五度!

2. 1. 是吗? 这里的秋天真漂亮!
 2. 是啊. 你看, 这红叶多美!

3. 1. 那么, 这里冬天的天气怎么样?
 2. 冬天很冷, 常常下大雪.

4. 1. 那么, 夏天呢?
 2. 夏天非常热! 可是春天很漂亮!

Skit 7
Where do You Live?
妳住在哪兒？

Skit 7
Where do You Live?
妳住在哪兒?

Dialogue: Pinyin

1. 1. Nǐ zhùzài nǎr?
 2. Wǒ zhù xuéxiào sùshè. Nǐ ne?

2. 1. Wǒ zhùzài Hépíng lù.
 2. Hépíng lù, shénme dìfang?

3. 1. Nǐ zhīdào Dìyī yínháng ma?
 2. Zhīdào.

4. 1. Wǒ jiā jiù zài Dìyī yínháng duìmiàn.

English Translation

1. 1. Where do you live?
 2. I live in the dorm. How about you?

2. 1. I live on Heping Road.
 2. Where on Heping Road?

3. 1. Do you know where the First Bank is?
 2. Yes.

4. 1. My home is right across from the First Bank.

Skit 7: Where Do You Live?

Vocabulary & Phrases

1.	zhù(zài)	to live (in, on, at)	住(在)
2.	zài	at, in, on	在
3.	nǎr	where?	哪兒
4.	xuéxiào	school	學校
5.	sùshè	dormitory	宿舍
6.	hépíng	peace	和平
7.	lù	road	路
8.	dìfang	place	地方
9.	zhīdào	to know	知道
10.	dìyī	the first, number one	第一
11.	dì	*prefix* for ordinal numbers	第
12.	yínháng	bank	銀行
13.	jiā	home, house	家
14.	jiù	for emphasizing	就
15.	duìmiàn	across from, opposite	對面

Skit 7

Dialogue: Traditional Characters

1. 1. 妳住在哪兒?
 2. 我住學校宿舍. 妳呢?

2. 1. 我住在和平路.
 2. 和平路, 甚麼地方?

3. 1. 妳知道第一銀行嗎?
 2. 知道.

4. 1. 我家就在第一銀行對面.

═══════════════════════════════════

Simplified Characters

1. 1. 妳住在哪儿?
 2. 我住学校宿舍. 妳呢?

2. 1. 我住在和平路.
 2. 和平路, 什么地方?

3. 1. 妳知道第一银行吗?
 2. 知道.

4. 1. 我家就在第一银行对面.

Skit 8
Inviting a Friend to Your House for Dinner
請朋友來家裏吃晚飯

Skit 8
Inviting a Friend to Your House for Dinner
請朋友來家裏吃晚飯

Dialogue: Pinyin

1. 1. Xià ge xīngqīliù wǎnshàng nǐ dǎsuàn zuò shénme?
 2. Yǒu shénme shì ma?

2. 1. Wǒ xiǎng qǐng nǐ lái wǒ jiā chī wǎnfàn.
 2. Bú yào le, tài máfan le!

3. 1. Yìdiǎnr dōu bù máfan. Jiù shì biànfàn.
 2. Hǎo, nà jiù xièxie le. Nǐ yào wǒ jǐ diǎn dào?

4. 1. Liù diǎn kěyǐ ma?
 2. Hǎo a. Xièxie.

English Translation

1. 1. Do you have plans for next Saturday evening?
 2. Why, what's up?

2. 1. I'd like to invite you to come to my house for dinner.
 2. Oh no, that's too much trouble!

3. 1. It's no trouble at all! It'll just be something simple.
 2. Okay, thank you! What time do you want me to come?

Skit 8: Inviting a Friend to Your House for Dinner

4.
 1. Is 6:00 okay?
 2. That's fine. Thank you.

Vocabulary & Phrases

1.	xià ge	next	下個
2.	ge	*measure word*	個
3.	xīngqīliù	Saturday	星期六
4.	dǎsuàn	to plan	打算
5.	zuò	to do	做
6.	lái	to come	來
7.	yìdiǎnr dōu bù	not at all	一點兒都不
8.	dōu	all	都
9.	máfan	trouble	麻煩
10.	jiù shì	it's only, it's just	就是
11.	biànfàn	simple food	便飯
12.	nà jiù (+V)	in that case then, . . .	那就 (+V)
13.	xièxie	thank you	謝謝
14.	jǐ diǎn	what time?	幾點
15.	dào	to come, to arrive	到
16.	liù	six	六

Skit 8

Dialogue: Traditional Characters

1. 1. 下個星期六晚上妳打算做甚麼?
 2. 有甚麼事嗎?

2. 1. 我想請妳來我家吃晚飯.
 2. 不要了, 太麻煩了!

3. 1. 一點兒都不麻煩!　就是便飯.
 2. 好, 那就謝謝了.　妳要我幾點到?

4. 1. 六點可以嗎?
 2. 好啊.　謝謝.

Simplified Characters

1. 1. 下个星期六晚上妳打算做什么?
 2. 有什么事吗?

2. 1. 我想请妳来我家吃晚饭.
 2. 不要了, 太麻烦了!

3. 1. 一点儿都不麻烦!　就是便饭.
 2. 好, 那就谢谢了.　妳要我几点到?

4. 1. 六点可以吗?
 2. 好啊.　谢谢.

Skit 9
Giving Someone a Ride
開車接送朋友

Skit 9
Giving Someone a Ride
開車接送朋友

Dialogue: Pinyin

1. 1. Nǐ dǎsuàn zěnme dào wǒ jiā qù?
 2. Wǒ xiǎng zuò gōngchē qù.

2. 1. Zuò gōngchē tài màn le! Wǒ kěyǐ qù jiē nǐ.
 2. Huì bu huì tài máfan nǐ le?

3. 1. Bù máfan. Wǒ wǔ diǎn bàn qù jiē nǐ, kěyǐ ma?
 2. Hǎo a.

4. 1. Wǎnfàn yǐhòu, wǒ yě kěyǐ sòng nǐ huí jiā.
 2. Nà tài hǎo le! Xièxie.

English Translation

1. 1. How do you plan to get to my house?
 2. I think I'll take the bus.

2. 1. Oh, the bus is too slow! I can pick you up.
 2. Won't that be too much trouble for you?

3. 1. It's no trouble. I'll pick you up at 5:30, okay?
 2. Okay.

Skit 9: Giving Someone a Ride

4. 1. After dinner I can also take you home.
 2. That would be wonderful! Thank you.

Vocabulary & Phrases

1.	zěnme	how?	怎麼
2.	dào . . . qù	to go to a place	到 . . . 去
3.	qù	to go	去
4.	zuò	to ride, to take (a bus, etc)	坐
5.	gōngchē	bus	公車
6.	huì bu huì . . .	will / won't it be . . . ?	會不會
7.	huì	will	會
8.	tài	too	太
9.	màn	slow	慢
10.	le	*co-occurs with* "tài"	了
11.	jiē (nǐ)	to pick (you) up	接 (妳)
12.	wǔ diǎn bàn	5:30	五點半
13.	bàn	half	半
14.	yǐhòu	after	以後
15.	yě	also, too	也
16.	sòng (nǐ)	to escort (you)	送 (妳)
17.	huí jiā	to go home	回家
18.	huí	to return	回

Skit 9

Dialogue: Traditional Characters

1. 1. 妳打算怎麼到我家去?
 2. 我想坐公車去.

2. 1. 坐公車太慢了! 我可以去接妳.
 2. 會不會太麻煩妳了?

3. 1. 不麻煩. 我五點半去接妳, 可以嗎?
 2. 好啊.

4. 1. 晚飯以後, 我也可以送妳回家.
 2. 那太好了! 謝謝.

Simplified Characters

1. 1. 妳打算怎么到我家去?
 2. 我想坐公车去.

2. 1. 坐公车太慢了! 我可以去接妳.
 2. 会不会太麻烦妳了?

3. 1. 不麻烦. 我五点半去接妳, 可以吗?
 2. 好啊.

4. 1. 晚饭以后, 我也可以送妳回家.
 2. 那太好了! 谢谢.

Skit 10
Asking a Friend to a Movie
約朋友去看電影

Skit 10
Asking a Friend to a Movie
約朋友去看電影

Dialogue: Pinyin

1. 1. Hē diǎnr chá.
 2. Xièxiè.

2. 1. Zhè ge xīngqīwǔ wǎnshàng, nǐ dǎsuàn zuò shénme?
 2. Wǒ hái bù zhīdào.

3. 1. Nǐ xiǎng bu xiǎng qù kàn diànyǐngr a?
 2. Hǎo a. Yǒu shénme hǎo diànyǐngr ma?

4. 1. Zài Dàhuá diànyǐng yuànr, tāmen zài yǎn "Měilì rénshēng." Tīngshuō hěn bú cuò.
 2. Hǎo, wǒmen kàn něi yì chǎng?

5. 1. Jiǔ diǎn de něi chǎng, zěnmeyàng?
 2. Kěyǐ.

6. 1. Hǎo.

English Translation

1. 1. Have some tea.
 2. Thank you.

2. 1. What are you planning to do this Friday night?

Skit 10: Asking a Friend to a Movie

 2. I don't know yet.

3. 1. Would you like to go to a movie?
 2. Sure. Are any good movies playing?

4. 1. At the Grand China Theater they're showing "A Beautiful Life." I hear it's very good.
 2. Fine, which show shall we go to?

5. 1. How about the 9:00 show?
 2. That's fine.

6. 1. Good.

Vocabulary & Phrases

1.	hē	to drink	喝
2.	chá	tea	茶
3.	haí	still	還
4.	Dà-huá	Grand China	大華
5.	diànyǐng yuànr	movie theater	電影院兒
6.	yuànr	a yard, a courtyard	院兒
7.	tāmen	they	他們
8.	zài yǎn	to be showing	在演
9.	zài (+V)	*indicates progressive action*	在 (+V)
10.	yǎn	to show (a performance)	演
11.	měilì	beautiful	美麗
12.	rénshēng	(human) life	人生
13.	tīngshuō	I hear (others say that . . .)	聽說
14.	něi	which?	哪
15.	chǎng	*measure word* for film	場

Skit 10

Dialogue: Traditional Characters

1. 1. 喝點兒茶.
 2. 謝謝.

2. 1. 這個星期五晚上, 妳打算做甚麽?
 2. 我還不知道.

3. 1. 妳想不想去看電影啊?
 2. 好啊. 有甚麽好電影嗎?

4. 1. 在大華電影院兒, 他們在演 "美麗人生". 聽說很不錯.
 2. 好, 我們看哪一場?

5. 1. 九點的那場, 怎麽樣?
 2. 可以.

6. 1. 好.

Simplified Characters

1. 1. 喝点儿茶.
 2. 谢谢.

2. 1. 这个星期五晚上, 妳打算做什么?
 2. 我还不知道.

3. 1. 妳想不想去看电影啊?
 2. 好啊. 有什么好电影吗?

Skit 10: Asking a Friend to a Movie

4. 1. 在大华电影院儿, 他们在演 "美丽人生". 听说很不错.
 2. 好, 我们看哪一场?

5. 1. 九点的那场, 怎么样?
 2. 可以.

6. 1. 好.

Skit 11
How Long Does It Take to Get There?
開車去要多久?

Skit 11
How Long Does It Take To Get There?
開車去要多久？

Dialogue: Pinyin

1. 1. Diànyǐng yuànr lí zhèr yuǎn bu yuǎn?
 2. Bú tài yuǎn.

2. 1. Kāichē qù yào duōjiǔ?
 2. Chàbuduō èrshí fēnzhōng jiù dào le.

3. 1. Tíngchē róngyì ma?
 2. Nàr fùjìn yǒu yí ge tíngchē chǎng. Zhèyàng hǎo bu hǎo? Nǐ lái wǒ jiā, wǒmen yíkuàir qù.

4. 1. Hǎo a. Wǒ bā diǎn bàn lái nǐ jiā.
 2. Hǎo de, wǒ děng nǐ.

English Translation

1. 1. Is the movie theater far from here?
 2. Not too far.

2. 1. How long will it take to drive there?
 2. It takes only about 20 minutes.

Skit 11: How Long Does It Take to Get There?

3. 1. Is it easy to park?
 2. There's a parking lot nearby. How about this? You come to my house, and we'll go together.

4. 1. Good. I'll come to your house at 8:30.
 2. Okay, I'll wait for you.

Vocabulary & Phrases

1. lí — from (regarding distance) — 離
2. zhèr — here — 這兒
3. yuǎn — far — 遠
4. bú tài (+SV) — not too . . . — 不太
5. kāichē — to drive — 開車
6. yào — to take, to need — 要
7. duōjiǔ — how long? — 多久
8. chàbuduō — about, approximately — 差不多
9. èrshí — twenty — 二十
10. fēnzhōng — minute(s) — 分鐘
11. tíngchē — to park (the car) — 停車
12. róngyì — easy — 容易
13. nàr — there — 那兒
14. fùjìn — nearby — 附近
15. yǒu yíge . . . — there is a . . . — 有一個
16. tíngchē chǎng — parking lot — 停車場
17. zhèyàng — thus, like this — 這樣
18. hǎo bu hǎo? — okay? how about it? — 好不好
19. yíkuàir — together — 一塊兒
20. děng (nǐ) — wait for (you) — 等 (妳)

Skit 11

Dialogue: Traditional Characters

1. 1. 電影院兒離這兒遠不遠?
 2. 不太遠.

2. 1. 開車去要多久?
 2. 差不多二十分鐘就到了.

3. 1. 停車容易嗎?
 2. 那兒附近有一個停車場. 這樣好不好? 妳來我家, 我們一塊兒去.

4. 1. 好啊. 我八點半來妳家.
 2. 好的, 我等妳.

Simplified Characters

1. 1. 电影院儿离这儿远不远?
 2. 不太远.

2. 1. 开车去要多久?
 2. 差不多二十分钟就到了.

3. 1. 停车容易吗?
 2. 那儿附近有一个停车场. 这样好不好? 妳来我家, 我们一块儿去.

4. 1. 好啊. 我八点半来妳家.
 2. 好的, 我等妳.

Skit 12
Asking Directions
問路

Skit 12
Asking Directions
問路

Dialogue: Pinyin

1. 1. Qǐng wèn, zhèr fùjìn yǒu méiyǒu yóujú?
 2. Yǒu a. Lí zhèr bú tài yuǎn.

2. 1. Nǐ néng bu néng gàosù wǒ zěnme zǒu?
 2. Nǐ cóng zhèr wǎng qián yìzhí zǒu, jiù shì Dì wǔ jiē. Zài Dì wǔ jiē nàlǐ zuǒ zhuǎn, ránhoù yìzhí zǒu. Guò liǎng ge hóng lǜ dēng, yóujú jiù zài nǐ yòu biānr.

3. 1. Duōxiè! Duōxiè!
 2. Bú xiè.

English Translation

1. 1. Excuse me, is there a post office near here?
 2. Yes. Not too far from here.

2. 1. Could you tell me how to get there?
 2. You go straight ahead from here, the first street you come to is Fifth Street. Turn left at Fifth, then go straight. Pass two traffic lights and the post office is right there to your right.

3. 1. Many thanks!
 2. Don't mention it.

Skit 12: Asking Directions

Vocabulary & Phrases

1.	yǒu méiyǒu	is there?	有沒有
2.	yóujú	post office	郵局
3.	néng	can, could	能
4.	gàosù wǒ	tell me	告訴我
5.	zěnme zǒu	how do (you) get there?	怎麼走
6.	zǒu	to walk	走
7.	cóng zhèr	from here	從這兒
8.	wǎng qián	ahead	往前
9.	wǎng	toward	往
10.	qián	forward, the front	前
11.	yìzhí zǒu	to go straight	一直走
12.	yìzhí	straight	一直
13.	dì wǔ	fifth	第五
14.	jiē	street	街
15.	nàlǐ	there	那裏
16.	zuǒ zhuǎn	to make a left turn	左轉
17.	zuǒ	left (side)	左
18.	zhuǎn	to make a turn	轉
19.	ránhòu	then, afterward	然後
20.	guò	to pass	過
21.	liǎng ge	two	兩個
22.	hóng lǜ dēng	traffic lights	紅綠燈
23.	lǜ	green	綠
24.	dēng	lights	燈
25.	nǐ yòu biānr	on your right	你右邊兒
26.	zài	to be located at	在
27.	yòu	right	右
28.	biānr	side	邊兒
29.	duō xiè	many thanks	多謝
30.	bú xiè	don't mention it	不謝

Skit 12

Dialogue: Traditional Characters

1. 1. 請問, 這兒附近有沒有郵局?
 2. 有啊. 離這兒不太遠.

2. 1. 妳能不能告訴我怎麼走?
 2. 你從這兒往前一直走, 就是第五街. 在第五街那裏左轉, 然後一直走. 過兩個紅綠燈, 郵局就在你右邊兒.

3. 1. 多謝! 多謝!
 2. 不謝.

Simplified Characters

1. 1. 请问, 这儿附近有没有邮局?
 2. 有啊. 离这儿不太远.

2. 1. 妳能不能告诉我怎么走?
 2. 你从这儿往前一直走, 就是第五街. 在第五街那里左转, 然后一直走. 过两个红绿灯, 邮局就在你右边儿.

3. 1. 多谢! 多谢!
 2. 不谢.

Skit 13
Talking About Your Family
談家人

Skit 13
Talking About Your Family
談家人

Dialogue: Pinyin

1. 1. Táo lǎoshī, zhè shì nǐ érzi ma?
 2. Shì a.

2. 1. Tā hěn shuài! Tā zhǎng de hěn xiàng nǐ.
 2. Shì ma? Zhè shì wǒ māma. Tā jīn nián bāshí suì le! Nǐ jiā lǐ dōu yǒu shénme rén?

3. 1. Wǒ jiā lǐ yǒu bàba, māma, yí ge gēge, yí ge jiějie, yí ge dìdi hé yí ge mèimei.
 2. Nǐ yǒu tāmen de zhàopiàn ma?

4. 1. Wǒ méi dài lái. Xià cì wǒ ná gěi lǎoshī kàn.
 2. Hǎo de.

English Translation

1. 1. Teacher Tao, is this your son?
 2. Yes.

2. 1. He's very handsome! He looks a lot like you.
 2. Really? This is my mother. She's 80 years old this year! Who is there in your family?

3. 1. There's my father and mother, my older brother, older sister, younger brother, and younger sister.

Skit 13: Talking About Your Family 53

 2. Do you have pictures of them?

4. 1. I didn't bring them. Next time I'll show you.
 2. OK.

Vocabulary & Phrases

1.	érzi	son	兒子
2.	shuài	handsome	帥
3.	zhǎngde	to grow	長得
4.	xiàng (nǐ)	to resemble (you)	像 (妳)
5.	māma	mother	媽媽
6.	tā	she	她
7.	jīnnián	this year	今年
8.	nián	year	年
9.	bāshí	eighty	八十
10.	suì	year of age	歲
11.	jiā lǐ	in (your) family	家裏
12.	shénme rén	who?	甚麼人
13.	bàba	father	爸爸
14.	gēge	older brother	哥哥
15.	jiějie	older sister	姐姐
16.	dìdi	younger brother	弟弟
17.	hé	and	和
18.	mèimei	younger sister	妹妹
19.	zhàopiàn	picture, photo	照片
20.	méi (+V)	didn't, haven't...	没 (+V)
21.	dài lái	to bring along	帶來
22.	xià cì	next time	下次
23.	ná gěi (nǐ) kàn	to show (you)	拿給 (妳) 看
24.	ná gěi	to take to, to bring to	拿給

Skit 13

Dialogue: Traditional Characters

1. 1. 陶老師, 這是妳兒子嗎?
 2. 是啊.

2. 1. 他很帥! 他長得很像妳.
 2. 是嗎? 這是我媽媽. 她今年八十歲了! 你家裏都有甚麼人?

3. 1. 我家裏有爸爸, 媽媽, 一個哥哥, 一個姐姐, 一個弟弟和一個妹妹.
 2. 你有他們的照片嗎?

4. 1. 我沒帶來. 下次我拿給老師看.
 2. 好的.

Simplified Characters

1. 1. 陶老师, 这是妳儿子吗?
 2. 是啊.

2. 1. 他很帅! 他长得很像妳.
 2. 是吗? 这是我妈妈. 她今年八十岁了! 你家里都有什么人?

3. 1. 我家里有爸爸, 妈妈, 一个哥哥, 一个姐姐, 一个弟弟和一个妹妹.
 2. 你有他们的照片吗?

4. 1. 我没带来. 下次我拿给老师看.
 2. 好的.

Skit 14
Buying a Gift
買禮物

Skit 14
Buying a Gift
買禮物

Dialogue: Pinyin

1. 1. Zhèige lǐbàitiān shì wǒ mèimei de shēngrì.
 2. Shì ma? Nǐ xiǎng gěi tā mǎi diǎnr shénme lǐwù?

2. 1. Nǐ juéde zhè jiàn máoyī zěnmeyàng?
 2. Hěn piàoliang. Tā chuān jǐ hàor?

3. 1. Tā chuān zhōng hàor. Tā bǐ wǒ ǎi yìdiǎnr. Hǎokàn ma?
 2. Hěn hǎokàn.

4. 1. Nà jiù mǎi le.
 2. Hǎo a.

English Translation

1. 1. This Sunday is my younger sister's birthday.
 2. Is it? What gift are you thinking of buying for her?

2. 1. What do you think of this sweater?
 2. It's really pretty. What size does she wear?

3. 1. She wears a medium. She's a little shorter than I am. Do you think this is pretty?
 2. Very pretty.

4. 1. Then I'll buy it.
 2. Good.

Vocabulary & Phrases

1.	lǐbàitiān	Sunday	禮拜天
2.	shēngrì	birthday	生日
3.	gěi (tā)	for (her)	給 (她)
4.	lǐwù	gift	禮物
5.	juéde	think, feel	覺得
6.	jiàn	*measure word* for clothing	件
7.	máoyī	sweater	毛衣
8.	chuān	to wear	穿
9.	jǐ hào	what size?	幾號
10.	hào	number, size	號
11.	zhōng hào	medium	中號
12.	zhōng	middle, central	中
13.	bǐ wǒ	than I	比我
14.	bǐ	compare	比
15.	ǎi	short (for people)	矮
16.	hǎokàn	pretty	好看

Skit 14

Dialogue: Traditional Characters

1. 1. 這個禮拜天是我妹妹的生日.
 2. 是嗎？ 妳想給她買點兒甚麼禮物?

2. 1. 妳覺得這件毛衣怎麼樣?
 2. 很漂亮. 她穿幾號?

3. 1. 她穿中號. 她比我矮一點兒. 好看嗎?
 2. 很好看.

4. 1. 那就買了.
 2. 好啊.

===

Simplified Characters

1. 1. 这个礼拜天是我妹妹的生日.
 2. 是吗？ 妳想给她买点儿什么礼物?

2. 1. 妳觉得这件毛衣怎么样?
 2. 很漂亮. 她穿几号?

3. 1. 她穿中号. 她比我矮一点儿. 好看吗?
 2. 很好看.

4. 1. 那就买了.
 2. 好啊.

Skit 15
You Speak Chinese Very Well!
你中文說得真好啊!

Skit 15
You Speak Chinese Very Well!
你中文說得眞好啊!

Dialogue: Pinyin

1. 1. Nǐde Zhōngwén shuō de zhēn hǎo a!
 2. Nǎlǐ, nǎlǐ. Nǐ tài kèqi le!

2. 1. Bú shì kèqi. Nǐde Zhōngwén shuō de zhēnde hěn biāozhǔn!
 2. Nǐ guòjiǎng le! Wǒ shuō de bù hǎo.

English Translation

1. 1. You speak Chinese very well!
 2. Not really. That's very kind of you!

2. 1. I'm not being polite. Your pronunciation is excellent!
 2. You're flattering me! I don't speak very well.

Skit 15: You Speak Chinese Very Well!

Vocabulary & Phrases

1. shuō de hǎo — to speak well — 說得好
2. nǎlǐ, nǎlǐ — not really (polite response to a compliment) — 哪裏哪裏
3. tài kèqi le — too polite — 太客氣了
4. kèqi — polite, kind — 客氣
5. zhēnde — really, truly — 眞的
6. biāozhǔn — standard, accurate — 標準
7. guòjiǎng — to overpraise, flatter — 過獎

Skit 15

Dialogue: Traditional Characters

1. 1. 你的中文說得真好啊!
 2. 哪裏, 哪裏.　你太客氣了!

2. 1. 不是客氣. 你的中文說得真的很標準!
 2. 你過獎了!　我說得不好.

Simplified Characters

1. 1. 你的中文说得真好啊!
 2. 哪里, 哪里.　你太客气了!

2. 1. 不是客气.　你的中文说得真的很标准!
 2. 你过奖了!　我说得不好.

Skit 16
When Did You Start Learning Chinese?
你是甚麼時候開始學中文的?

Skit 16
When Did You Start Learning Chinese?
你是甚麼時候開始學中文的?

Dialogue: Pinyin

1. 1. Nǐ shì shénme shíhòu kāishǐ xué Zhōngwén de?
 2. Wǒ wǔ suì jiù kāishǐ xué le!

2. 1. Nǐ shì zài shénme dìfang xué de?
 2. Wǒ shì zài Táiwān xué de.

3. 1. Nǐ wèishénme yào xué Zhōngwén ne?
 2. Wǒ fùmǔ jiào wǒ xué de.

English Translation

1. 1. When did you start learning Chinese?
 2. I started when I was just five years old!

2. 1. Where did you learn it?
 2. I learned it in Taiwan.

3. 1. Why did you study Chinese?
 2. Because my parents told me to.

Skit 16: When Did You Start Learning Chinese?

Vocabulary & Phrases

1. shénme shíhòu — when? — 甚麼時候
2. shíhòu — time — 時候
3. kāishǐ — to start — 開始
4. xué — to learn — 學
5. Zhōngwén — Chinese language — 中文
6. de — *"de" in the "shì...de" pattern* — 的
7. jiù — *indicates that something happened "early"* — 就
8. Táiwān — Taiwan — 台灣
9. wèishénme — why? — 為甚麼
10. fùmǔ — parents — 父母
11. jiào wǒ (+V) — to tell me to... — 叫我 (+V)

Skit 16

Dialogue: Traditional Characters

1. 1. 你是甚麼時候開始學中文的?
 2. 我五歲就開始學了!

2. 1. 你是在甚麼地方學的?
 2. 我是在台灣學的.

3. 1. 你為甚麼要學中文呢?
 2. 我父母叫我學的.

Simplified Characters

1. 1. 你是什么时候开始学中文的?
 2. 我五岁就开始学了!

2. 1. 你是在什么地方学的?
 2. 我是在台湾学的.

3. 1. 你为什么要学中文呢?
 2. 我父母叫我学的.

Skit 17
When Did You Come to the U.S.?
你甚麼時候到美國來的?

Skit 17
When Did You Come to the U.S.?
你甚麼時候到美國來的？

Dialogue: Pinyin

1. 1. Nǐ shénme shíhoù dào Měiguó lái de?
 2. Wǒ shì yī jiǔ jiǔ yī nián bāyuè lái de.

2. 1. Nǐ zài zhèige dìfang zhù le duōjiǔ le?
 2. Wǒ zài zhèr zhù le cái sìge yuè. Nǐ ne?
 Nǐ zài zhèr zhù le duōjiǔ le?

3. 1. Kuài liǎng nián le!

English Translation

1. 1. When did you come to the U.S.?
 2. I came in August 1991.

2. 1. How long have you been living here?
 2. I've been *here* only four months. How about you?
 How long have you been here?

3. 1. Almost two years!

Skit 17: When Did You Come to the U.S.?

Vocabulary & Phrases

1. Měiguó — United States — 美國
2. bāyuè — August — 八月
3. cái — only, just — 才
4. yuè — month — 月
5. kuài — almost, nearly — 快

Skit 17

Dialogue: Traditional Characters

1. 1. 你甚麼時候到美國來的?
 2. 我是一九九一年八月來的.

2. 1. 你在這個地方住了多久了?
 2. 我在這兒住了才四個月. 你呢? 你在這兒住了多久了?

3. 1. 快兩年了!

═══════════════════════════════════════

Simplified Characters

1. 1. 你什么时候到美国来的?
 2. 我是一九九一年八月来的.

2. 1. 你在这个地方住了多久了?
 2. 我在这儿住了才四个月. 你呢? 你在这儿住了多久了?

3. 1. 快两年了!

Skit 18
I Like Your Outfit!
妳這件衣服真漂亮!

Skit 18
I Like Your Outfit!
妳這件衣服眞漂亮!

Dialogue: Pinyin

1. 1. Hē diǎnr chá.
 2. Xièxie.

2. 1. Nǐ zhè jiàn yīfu zhēn piàoliang! Zài shénme dìfang mǎi de?
 2. Wǒ shì zài bǎihuò gōngsī mǎi de.

3. 1. Yídìng hěn guì ba!
 2. Hái hǎo. Wǒ shì jiǎn jià de shíhòu mǎi de.

4. 1. Nǐ chuān lǜsè hěn hǎokàn!
 2. Zhēnde?

5. 1. Zhēnde!

English Translation

1. 1. Have some tea.
 2. Thank you.

2. 1. Your dress is really beautiful! Where did you buy it?
 2. I got it at a department store.

3. 1. It must have been very expensive!
 2. It wasn't too bad. I bought it on sale.

Skit 18: I Like Your Outfit!

4. 1. Green is a good color on you!
 2. Really?

5. 1. Really!

Vocabulary & Phrases

1.	yīfu	clothing	衣服
2.	bǎihuò gōngsī	department store	百貨公司
3.	bǎi	a hundred	百
4.	huò	goods	貨
5.	gōngsī	company	公司
6.	yídìng	must be, for sure	一定
7.	guì	expensive	貴
8.	hái hǎo	okay, not bad	還好
9.	jiǎn jià	to put on sale, reduce price	減價
10.	jiǎn	to subtract, reduce	減
11.	jià	price	價
12.	sè	color	色

Skit 18

Dialogue: Traditional Characters

1. 1. 喝點兒茶.
 2. 謝謝.

2. 1. 妳這件衣服真漂亮! 在甚麼地方買的?
 2. 我是在百貨公司買的.

3. 1. 一定很貴吧!
 2. 還好. 我是減價的時候買的.

4. 1. 妳穿綠色很好看!
 2. 真的?

5. 1. 真的!

Simplified Characters

1. 1. 喝点儿茶.
 2. 谢谢.

2. 1. 妳这件衣服真漂亮! 在什么地方买的?
 2. 我是在百货公司买的.

3. 1. 一定很贵吧!
 2. 还好. 我是减价的时候买的.

4. 1. 妳穿绿色很好看!
 2. 真的?

5. 1. 真的!

Skit 19
When Is Your Birthday?
妳生日是哪天?

Skit 19
When Is Your Birthday?
妳生日是哪天?

Dialogue: Pinyin

1. 1. Nǐ shēngrì shì něi tiān?
 2. Wǒ shēngrì shì sānyuè shíqī hào.

2. 1. Nǐ něi nián shēng de?
 2. Wǒ yī jiǔ bā líng nián shēng de.

3. 1. Nǐ zài nǎr shēng de?
 2. Wǒ zài Běijīng shēng de.

English Translation

1. 1. When is your birthday?
 2. My birthday is March 17th.

2. 1. What year were you born?
 2. I was born in 1980.

3. 1. Where were you born?
 2. I was born in Beijing.

Skit 19: When Is Your Birthday?

Vocabulary & Phrases

1. sānyuè — March — 三月
2. shíqī hào — 17th — 十七號
3. shēng — to be born — 生
4. líng — zero — 零
5. Běijīng — Beijing — 北京

Skit 19

Dialogue: Traditional Characters

1. 1. 妳生日是哪天?
 2. 我生日是三月十七號.

2. 1. 妳哪年生的?
 2. 我一九八零年生的.

3. 1. 妳在哪兒生的?
 2. 我在北京生的.

Simplified Characters

1. 1. 妳生日是哪天?
 2. 我生日是三月十七号.

2. 1. 妳哪年生的?
 2. 我一九八零年生的.

3. 1. 妳在哪儿生的?
 2. 我在北京生的.

Skit 20
What's Your Major?
你是學甚麼的?

Skit 20
What's Your Major?
你是學甚麼的?

Dialogue: Pinyin

1. 1. Nǐ shì xué shénme de?
 2. Wǒ xué shāng.

2. 1. Xiànzài nǐ niàn jǐ niánjí?
 2. Wǒ niàn dàxué sì niánjí.

3. 1. A, nǐ kuài bìyè le ba?
 2. Shì a, wǒ míngnián wǔyuè bìyè.

English Translation

1. 1. What's your major?
 2. I'm majoring in business.

2. 1. What year are you now?
 2. I'm a senior.

3. 1. So, you're about to graduate?
 2. Yes, I'll graduate in May of next year.

Skit 20: What's Your Major?

Vocabulary & Phrases

1.	shāng	business	商
2.	xiànzài	now	現在
3.	niàn	to study	念
4.	niánjí	grade, year	年級
5.	dàxué	university	大學
6.	bìyè	to graduate	畢業
7.	míngnián	next year	明年
8.	wǔyuè	May	五月

Skit 20

Dialogue: Traditional Characters

1. 1. 你是學甚麼的?
 2. 我學商.

2. 1. 現在你念幾年級?
 2. 我念大學四年級.

3. 1. 啊, 你快畢業了吧?
 2. 是啊, 我明年五月畢業.

Simplified Characters

1. 1. 你是学什么的?
 2. 我学商.

2. 1. 现在你念几年级?
 2. 我念大学四年级.

3. 1. 啊, 你快毕业了吧?
 2. 是啊, 我明年五月毕业.

Skit 21
What Do You Plan to Do After Graduation?
畢業以後, 你打算做甚麼?

Skit 21
What Do You Plan to Do After Graduation?
畢業以後, 你打算做甚麼?

Dialogue: Pinyin

1. 1. Nǐ shénme shíhoù dàxué bìyè?
 2. Míngnián wǔyuè.

2. 1. Bìyè yǐhoù, nǐ dǎsuàn zuò shénme?
 2. Wǒ xiǎng xiān zhǎo yí fèn gōngzuò.

3. 1. Nǐ kāishǐ zhǎo le ma?
 2. Zhèngzài zhǎo.

4. 1. Nǐ xiǎng qù shénme dìfang zuòshì?
 2. Wǒ xiǎng qù Niǔyuē zuòshì, yīnwèi wǒ zài Niǔyuē yǒu hěnduō péngyou.

English Translation

1. 1. When are you going to graduate from college?
 2. Next May.

2. 1. What do you plan to do after graduation?
 2. I'm thinking of first looking for a job.

3. 1. Have you started looking ?
 2. I'm just in the process.

Skit 21: What Do You Plan to Do After Graduation?

4.
 1. Where would you like to work?
 2. I'd like to work in New York because I have a lot of friends there.

Vocabulary & Phrases

1.	xiān	first	先
2.	zhǎo	to look for	找
3.	fèn	*measure word* for job	份
4.	gōngzuò	a job	工作
5.	zhèngzài (+V)	*indicates progressive action, to be in the middle of...*	正在 (+V)
6.	zuòshì	to work	做事
7.	Niǔyuē	New York	紐約
8.	yīnwèi	because	因為
9.	hěnduō	a lot, many	很多
10.	péngyou	friends	朋友

Skit 21

Dialogue: Traditional Characters

1. 1. 你甚麼時候大學畢業?
 2. 明年五月.

2. 1. 畢業以後, 你打算做甚麼?
 2. 我想先找一份工作.

3. 1. 你開始找了嗎?
 2. 正在找.

4. 1. 你想去甚麼地方做事?
 2. 我想去紐約做事, 因為我在紐約有很多朋友.

Simplified Characters

1. 1. 你什么时候大学毕业?
 2. 明年五月.

2. 1. 毕业以后, 你打算做什么?
 2. 我想先找一份工作.

3. 1. 你开始找了吗?
 2. 正在找.

4. 1. 你想去什么地方做事?
 2. 我想去纽约做事, 因为我在纽约有很多朋友.

Skit 22
Moving to a New Apartment
搬家

Skit 22
Moving to a New Apartment
搬家

Dialogue: Pinyin

1. 1. Táo lǎoshī, wǒ xià ge xīngqī yào bān jiā le.
 2. Zhēnde ma?

2. 1. Wǒmen zhǎodào yí ge gōngyù. Yǒu sān jiān wòshì, yí ge chúfáng, hái yǒu yí ge hěn dà de kètīng!
 2. Fángzū guì bu guì?

3. 1. Hái hǎo. Wǒmen yǒu sān ge rén. Měi ge rén yí ge yuè fù sānbǎi wǔshí kuài.
 2. Nà tài hǎo le! Bié wàng le gěi wǒ nǐde xīn diànhuà.

4. 1. Dāngrán le!

English Translation

1. 1. Teacher Tao, I will be moving next week.
 2. Really?

2. 1. We found an apartment with three bedrooms, a kitchen, and a *very* large living room!
 2. Is the rent expensive?

3. 1. It's okay. There are three of us. Each one pays $350 a month.

Skit 22: Moving to a New Apartment

2. That's great! Don't forget to give me your new phone number.

4. 1. Of course!

Vocabulary & Phrases

1.	bān jiā	to move	搬家
2.	zhǎodào	to have found	找到
3.	gōngyù	an apartment	公寓
4.	jiān	*measure word* for rooms	間
5.	wòshì	bedroom	臥室
6.	chúfáng	kitchen	廚房
7.	kètīng	living room	客廳
8.	fángzū	rent	房租
9.	měi	each	每
10.	rén	person	人
11.	fù	to pay	付
12.	sānbǎi	three hundred	三百
13.	wǔshí	fifty	五十
14.	bié +V	don't . . .	別
15.	wàng	to forget	忘
16.	gěi wǒ	to give me	給我
17.	nǐde	your	你的
18.	xīn	new	新
19.	diànhuà	phone number, telephone	電話
20.	dāngrán	of course	當然

Skit 22

Dialogue: Traditional Characters

1. 1. 陶老師, 我下個星期要搬家了.
 2. 真的嗎?

2. 1. 我們找到一個公寓. 有三間臥室, 一個廚房, 還有一個很大的客廳!
 2. 房租貴不貴?

3. 1. 還好. 我們有三個人. 每個人一個月付三百五十塊.
 2. 那太好了! 別忘了給我你的新電話.

4. 1. 當然了!

Simplified Characters

1. 1. 陶老师, 我下个星期要搬家了.
 2. 真的吗?

2. 1. 我们找到一个公寓. 有三间卧室, 一个厨房, 还有一个很大的客厅!
 2. 房租贵不贵?

3. 1. 还好. 我们有三个人. 每个人一个月付三百五十块.
 2. 那太好了! 别忘了给我你的新电话.

4. 1. 当然了!

Skit 23
How Often Do You Call Your Parents?
你多久給父母打一次電話？

Skit 23
How Often Do You Call Your Parents?
你多久給父母打一次電話？

Dialogue: Pinyin

1. 1. Nǐ cháng gěi nǐ fùmǔ xiě xìn ma?
 2. Xiě xìn tài máfan le! Wǒ gěi tāmen dǎ diànhuà.

2. 1. Nǐ duōjiǔ gěi tāmen dǎ yí cì diànhuà?
 2. Wǒ měi ge xīngqī gěi tāmen dǎ liǎng cì diànhuà.

3. 1. Wa! Nǐ diànhuà fèi yídìng hěn guì ba!
 2. Chángtú diànhuà <u>shì</u> hěn guì, búguò wǒ fùmǔ fù wǒde diànhuà fèi.

4. 1. Nǐ fùmǔ duì nǐ zhēn hǎo!
 2. Shì a! Tāmen fēicháng téng wǒ!

English Translation

1. 1. Do you write to your parents often?
 2. It's too much trouble to write! I call them.

2. 1. How often do you call?
 2. I call them twice a week.

3. 1. Wow! Your phone bills must be very high!

2. Yes. Long distance calls *are* expensive. But my parents pay the phone bills.

4.
 1. Your parents are really nice to you!
 2. Yes, they love me very much!

Vocabulary & Phrases

1.	gěi . . . xiě xìn	to write to . . .	給 . . . 寫信
2.	xiě xìn	to write letters	寫信
3.	xìn	letters	信
4.	gěi . . . dǎ diànhuà	to call . . . on the phone	給 . . . 打電話
5.	dǎ diànhuà	to make a phone call	打電話
6.	fèi	expenses, fees	費
7.	chángtú	long distance	長途
8.	cháng	long	長
9.	tú	road, route	途
10.	búguò	however, but	不過
11.	duì . . . hǎo	to be nice to . . .	對 . . . 好
12.	téng	to be fond of	疼

Skit 23

Dialogue: Traditional Characters

1. 1. 你常給你父母寫信嗎?
 2. 寫信太麻煩了! 我給他們打電話.

2. 1. 你多久給他們打一次電話?
 2. 我每個星期給他們打兩次電話.

3. 1. 哇! 你電話費一定很貴吧!
 2. 長途電話是很貴, 不過我父母付我的電話費.

4. 1. 你父母對你真好!
 2. 是啊! 他們非常疼我!

Simplified Characters

1. 1. 你常给你父母写信吗?
 2. 写信太麻烦了! 我给他们打电话.

2. 1. 你多久给他们打一次电话?
 2. 我每个星期给他们打两次电话.

3. 1. 哇! 你电话费一定很贵吧!
 2. 长途电话是很贵, 不过我父母付我的电话费.

4. 1. 你父母对你真好!
 2. 是啊! 他们非常疼我!

Skit 24
Have You Ever Been to China?
你去過中國嗎?

Skit 24
Have You Ever Been to China?
你去過中國嗎?

Dialogue: Pinyin

1. 1. Nǐ qùguo Zhōngguó ma?
 2. Qùguo yí cì.

2. 1. Nǐ shénme shíhou qù de?
 2. Liǎng nián yǐqián, gēn wǒ tóngxué yíkuàir qù de.

3. 1. Nǐ qùguo něi xiē dìfang ne?
 2. Qùguo Běijīng, Shànghǎi, Guǎngzhōu.

4. 1. Nǐ yǒu méiyǒu qù kànkan Chángchéng ne?
 2. Qù le! Wǒ hái zài Chángchéng shàng shuìguo jiào ne!

5. 1. Zhēnde ma?
 2. Zhēnde!

6. 1. Wa! Nǐ dǎnzi zhēn dà a!

English Translation

1. 1. Have you ever been to China?
 2. I was there once.

2. 1. When did you go?
 2. Two years ago. I went with my classmates.

Skit 24: Have You Ever Been to China?

3. 1. Where did you go?
 2. I went to Beijing, Shanghai, Canton.

4. 1. Did you visit the Great Wall?
 2. I did. I even slept overnight there!

5. 1. Really?
 2. Really!

6. 1. Wow! You're really daring!

Vocabulary & Phrases

1.	V+ guo	*indicates past experience*	V+ 過
2.	Zhōngguó	China	中國
3.	yǐqián	ago, before	以前
4.	gēn	with, and	跟
5.	tóngxué	classmate(s)	同學
6.	xiē	some, few (*measure word*)	些
7.	Shànghǎi	Shanghai	上海
8.	Guǎngzhōu	Canton	廣州
9.	kànkan	to take a look, to visit	看看
10.	Chángchéng	Great Wall	長城
11.	shuì jiào	to sleep	睡覺
12.	dǎnzi dà	daring, audacious	膽子大
13.	dǎnzi	the gall, bravado	膽子

Skit 24

Dialogue: Traditional Characters

1. 1. 你去過中國嗎?
 2. 去過一次.

2. 1. 你甚麼時候去的?
 2. 兩年以前, 跟我同學一塊兒去的.

3. 1. 你去過哪些地方呢?
 2. 去過北京, 上海, 廣州.

4. 1. 你有沒有去看看長城呢?
 2. 去了! 我還在長城上睡過覺呢!

5. 1. 眞的嗎?
 2. 眞的!

6. 1. 哇! 你膽子眞大啊!

Simplified Characters

1. 1. 你去过中国吗?
 2. 去过一次.

2. 1. 你什么时候去的?
 2. 两年以前, 跟我同学一块儿去的.

3. 1. 你去过哪些地方呢?
 2. 去过北京, 上海, 广州.

Skit 24: Have You Ever Been to China?

4. 1. 你有没有去看看长城呢?
 2. 去了! 我还在长城上睡过觉呢!

5. 1. 真的吗?
 2. 真的!

6. 1. 哇! 你胆子真大啊!

Skit 25
How Long Have You Known Each Other?
你們認識多久了?

Skit 25
How Long Have You Known Each Other?
你們認識多久了?

Dialogue: Pinyin

1. 1. Gǎnēnjié nǐ yào dào nǎr qù?
 2. Wǒ yào qù kàn wǒ nǚ péngyou. Wǒ liǎng ge duō yuè méi kàndào tā le!

2. 1. Shì ma? Nǐmen rènshi duōjiǔ le?
 2. Wǒmen rènshi kuài bàn nián le.

3. 1. Nǐmen shì zěnme rènshi de?
 2. Wǒmen zài yí ge wǔhuì shàng rènshi de. Wǒmen liǎng ge rén dōu xǐhuān tiàowǔ.

English Translation

1. 1. Where will you be for Thanksgiving?
 2. I am going to see my girl friend. I haven't seen her for more than two months!

2. 1. Really? How long have you known each other?
 2. We've known each other for almost half a year.

3. 1. How did you meet?
 2. We met at a dance party. We both like to dance.

Skit 25: How Long Have You Known Each Other?

Vocabulary & Phrases

1.	Gǎnēnjié	Thanksgiving	感恩節
2.	nǚ péngyou	girl friend	女朋友
3.	nǚ	female	女
4.	kàndào	to see	看到
5.	rènshi	to know someone	認識
6.	wǔhuì	dance party	舞會
7.	xǐhuān	to like	喜歡
8.	tiàowǔ	to dance	跳舞

Skit 25

Dialogue: Traditional Characters

1. 1. 感恩節你要到哪兒去?
 2. 我要去看我女朋友．我兩個多月沒看到她了!

2. 1. 是嗎? 你們認識多久了?
 2. 我們認識快半年了．

3. 1. 你們是怎麼認識的?
 2. 我們在一個舞會上認識的．我們兩個人都喜歡跳舞．

Simplified Characters

1. 1. 感恩节你要到哪儿去?
 2. 我要去看我女朋友．我两个多月没看到她了!

2. 1. 是吗? 你们认识多久了?
 2. 我们认识快半年了．

3. 1. 你们是怎么认识的?
 2. 我们在一个舞会上认识的．我们两个人都喜欢跳舞．

Skit 26
Asking for a Phone Number and Address
要電話地址

Skit 26
Asking for a Phone Number and Address
要電話地址

Dialogue: Pinyin

1. 1. Kě bu kěyǐ bǎ nǐ de diànhuà gěi wǒ?
 2. Dāngrán kěyǐ! Wǒ diànhuà shì èr-sì-yī, sān-wǔ-jiǔ-bā.

2. 1. Bǎ nǐde dìzhǐ yě gěi wǒ, hǎo bu hǎo?
 2. Wǒ dìzhǐ shì Gōngyuán lù sìbǎi qīshíliù hào.

English Translation

1. 1. Could you give me your telephone number?
 2. Of course! My phone number is 241-3598.

2. 1. Can I also get your address?
 2. Yes. My address is 476 Park Road.

Skit 26: Asking for a Phone Number and Address

Vocabulary & Phrases

1. bǎ ... gěi wǒ — give me ... — 把...給我
2. bǎ — *marker* indicates doing something to/about a specific object — 把
3. dìzhǐ — address — 地址
4. gōngyuán — park, public garden — 公園

Skit 26

Dialogue: Traditional Characters

1. 1. 可不可以把你的電話給我?
 2. 當然可以! 我電話是二四一三五九八.

2. 1. 把你的地址也給我, 好不好?
 2. 我地址是公園路四百七十六號.

Simplified Characters

1. 1. 可不可以把你的电话给我?
 2. 当然可以! 我电话是二四一三五九八.

2. 1. 把你的地址也给我, 好不好?
 2. 我地址是公园路四百七十六号.

Skit 27
What Are You Going to Do This Summer?
今年暑假妳打算做甚麼?

Skit 27
What Are You Going to Do This Summer?
今年暑假妳打算做甚麼?

Dialogue: Pinyin

1. 1. Jīnnián shǔjià nǐ dǎsuàn zuò shénme?
 2. Wǒ yào huí Táiwān kàn wǒ māma.

2. 1. Shénme shíhoù qù?
 2. Sìyuè dǐ.

3. 1. Qù duōjiǔ?
 2. Chàbuduō sì ge lǐbài ba.

4. 1. Nǐ cháng huí Táiwān ma?
 2. Wǒ měi nián dōu huíqù yí cì.

English Translation

1. 1. What are you planning to do for summer vacation?
 2. I'm going to Taiwan to visit my mother.

2. 1. When are you going?
 2. The end of April.

3. 1. How long will you stay?
 2. About four weeks.

Skit 27: What Are You Going to Do This Summer?

4. 1. Do you go back to Taiwan often?
 2. I go back once every year.

Vocabulary & Phrases

1.	shǔjià	summer vacation	暑假
2.	shǔ	summer	暑
3.	jià	vacation	假
4.	sìyuè	April	四月
5.	dǐ	the end of a month or a year	底
6.	lǐbài	a week	禮拜
7.	huíqù	to go back	回去

Skit 27

Dialogue: Traditional Characters

1. 1. 今年暑假妳打算做甚麼?
 2. 我要回台灣看我媽媽.

2. 1. 甚麼時候去?
 2. 四月底.

3. 1. 去多久?
 2. 差不多四個禮拜吧.

4. 1. 妳常回台灣嗎?
 2. 我每年都回去一次.

Simplified Characters

1. 1. 今年暑假妳打算做什么?
 2. 我要回台湾看我妈妈.

2. 1. 什么时候去?
 2. 四月底.

3. 1. 去多久?
 2. 差不多四个礼拜吧.

4. 1. 妳常回台湾吗?
 2. 我每年都回去一次.